Debra J. DeWitte ● Ralph M. Larmann ● M. Kathryn Shields

GATEWAYS TO ART

Journal

for Museum and Gallery Projects

SECOND EDITION

Thames & Hudson

Gateways to Art Journal copyright © 2015 Thames & Hudson

Text copyright © 2015 Debra J. DeWitte, Ralph M. Larmann, and M. Kathryn Shields

First published in 2015 in paperback in the United States of America by Thames & Hudson Inc., 500 Fifth Avenue, New York, New York 10110

thamesandhudsonusa.com

Reprinted 2016

Library of Congress Catalog Card Number 2015936444

ISBN 978-0-500-29216-7

Designed by Geoff Penna and Carla Turchini

Printed and bound in Malaysia by Times Offset (M) Sdn. Bhd.

Illustration Credits

All images are listed by illustration number.

Front cover
Taj Mahal, Agra, India © Steve Allen/Dreamstime.com

All images Ralph Larmann except: **1** © Richard Cummins/Corbis; **6** Courtesy, Creativemyndz Multimedia Studios, 2012; **21** Library of Congress, Prints & Photographs Division, H. Irving Olds collection, LC-DIG-jpd-02018; **23** © Tibor Bognar/Photononstop/Corbis; **26** George Eastman House, New York; **28** Musées Royaux des Beaux-Arts de Belgique, Brussels; **33** British Museum, London; **34** V&A Images/Victoria & Albert Museum; **35** from *Works of Geoffrey Chaucer*, Kelmscott Press, 1896; **36** The Art Institute of Chicago, Mr. and Mrs. Carter H. Harrison Collection, 1954.1193; **37** Nimatallah/akg-images; **40** The Nelson-Atkins Museum of Art, Kansas City, Missouri. Gift of the Friends of Art, F76-40. © Estate of Duane Hanson/VAGA, New York/DACS, London 2015; **41** © Cindy Wright; **42** Photo Russell Johnson. Courtesy Lino Tagliapietra, Inc.; **43** Library of Congress, Washington, D.C. Prints & Photographs Division, FSA/OWI Collection, LC-DIG-fsa-8b29516; **44** Barber Institute of Fine Arts, Birmingham, UK; **45** Musée D'Orsay, Paris; **46** The Cleveland Museum of Art, Purchase from the J.H. Wade Fund 1930.331; **47** © Sam74100/Dreamstime.com; **48** Toledo Museum of Art, Ohio. Photo courtesy of Richard P. Goodbody, Inc. *Niijima Floats* © Dale Chihuly; **49** High Museum of Art, Atlanta, 1999.93. Purchase with the T. Marshall Hahn Folk Art Acquisition Fund for the T. Marshall Hahn Collection; **50** The Museum of Fine Arts, Houston, The Hogg Brothers Collection, gift of Miss Ima Hogg; **51** Museum of Modern Art, New York, acquired through the Lillie P. Bliss Bequest, 333.1939. Digital image 2011, The Museum of Modern Art, New York/Scala, Florence. © Succession Picasso/DACS, London 2015; **52** Courtesy Alessi S.p.A., Crusinallo, Italy; **53** Photo courtesy Birmingham Museum of Art, Alabama; **54** © Roka22/Dreamstime.com; **55** © Felixcasio/Dreamstime.com; **56** Museo Nacional del Prado, Madrid.

Contents

How to Use This Journal **3**

Planning Your Visit **4**
 General Museum Information 5

Looking at Art
 Visual Analysis 6
 Media 22
 Representational, Non-Objective, Abstract 28
 Modes of Analysis 29
 History 30
 Theme 31
 Summary of Visual Analysis 32

Understanding What Museums Do **33**
 Museums Evolve over Time 34
 Museums Preserve Our Heritage 36
 Museums Shape Our Experience of Art 38
 Museums Reach out to the Public 42
 A Global Museum for a Global World 44

Glossary **45**

How to Use this Journal

When you visit a museum or gallery, you will be surrounded by a wealth of artworks. While you will find much that will inspire you, there will also be too much to absorb in a single visit. This journal aims to help you get the most out of your time at the museum by focusing your attention on what you see. This will help you to gain a better understanding of specific works and identify related or contrasting works in the museum's collection.

Start by reading the guidelines given in "Planning Your Visit" (pp. 4–5). Then work through each page of this journal.

The "Visual Analysis" (pp. 6–21) section will introduce you to the elements and principles of art and help you understand how they have been applied to the artworks you see in front of you.

A section on "Media" (pp. 22–27) concentrates on the materials and techniques artists use. One of the best things about going to see artworks up close is that you can really appreciate how much work went into creating each one, and how the artist went about his or her craft.

In the sections on "Representational, Non-Objective, Abstract" and "Modes of Analysis," (pp. 28–29) you can focus on understanding the content of a work. These sections encourage you to think about different ways you could interpret what is in the artwork.

Any museum or gallery is a rich source of historical information, and the "History" section (p. 30) offers advice on what to look out for when you are there. The people who have created the displays will already have done a lot of thinking for you, grouping works together in certain ways to help you get a better grasp of different influences and periods of art history.

The "Theme" section (p. 31) will guide you to recognize important ideas and emotions that have inspired artists all over the world and all through time to express themselves through art. It is fascinating to compare how a particular theme can be depicted in so many different ways.

Throughout this journal, you will find space for making notes about what you are looking at. You can also make sketches of what you see: drawing, whether simply copying what is in front of you or working out in a sketch how, for example, the principle of line has been applied in a painting, is a very immediate way of understanding what is involved in the creation of art.

Finally, the section on "Understanding What Museums Do" (pp. 33–44) is designed to take you behind the scenes at a variety of museums, so that you will be prepared for your own visit. As you will see, no two museums are the same; like people, museums have their own identities and profiles. Each offers different facilities to help you with your project. Finding out in advance about your local museum and how you can benefit from its services will make your time there all the more enjoyable.

Planning Your Visit

Museums are storehouses for our cultural treasures. Some focus on specific periods and cultures. Galleries frequently change the artwork they display, and offer special exhibitions showcasing the work of contemporary and local artists. Artworks in a gallery are often for sale, but works owned by a museum are held in its care long term. Ask your professor which museums and galleries in your area she would recommend.

Often, museums were built by renowned architects, and are therefore works of art in themselves. As museum staff take pride in their collections, and are concerned for the valuable objects in their care, museums often have strict rules. The architecture itself can also be somewhat forbidding. Don't let such rules, or a building's imposing **facade**, make you feel unwelcome (**1**). Remember that the artwork is being displayed for you.

Let yourself wander through the museum, stopping to consider works that intrigue you. Everyone's taste is unique, and it is better to focus on a few works than to overwhelm yourself trying to understand the museum's entire collection in one day. When you come upon an artwork you would like to write about or sketch, stop and consider what it is that drew you to it. Do you love it? Hate it? Do you find it beautiful or ugly? Are you curious about the characters in the scene? Or are you confused by what the artist is trying to say? Use the textbook, class notes, and museum labels to help you understand the

1 Cleveland Museum of Art, Ohio

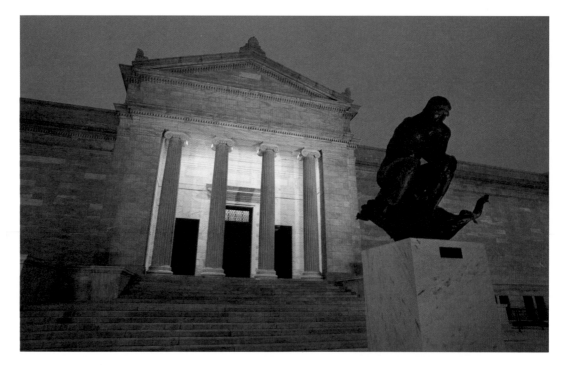

artwork. But do not forget to take ample time to look at the artwork in detail. This journal will help you to do this.

You can make the most of your visit to a local art museum or gallery if you plan ahead. Based on what your teacher advises, choose a museum to visit. Research the items in the table below online before you go so that you can make the most of your time with the exhibits.

General Museum Information

What to take with you

- ☑ Your assignment
- ☑ This journal
- ☑ Pencils (and pens, if allowed)
- ☑ Printouts of images you like from the museum's website

While you are there

Museum and gallery projects often require you to study one work in detail, or to compare and contrast two works. The experience of seeing works in a museum or gallery is the best way to enjoy and learn about art. Take a little time to look at other works, not just the ones you are studying for your assignment. Artworks displayed in the same room may well be by the same artist, or from the same era or culture. You may notice something in these pieces that will inspire extra ideas for your assignment.

Artwork labels: There are usually labels next to each artwork. These labels contain useful information about the work, which can help you write a really great assignment. Do not forget to make notes of the details given in the labels. The museum bookstore and website will help you find more material about the artwork you select.

Museum and gallery dos and don'ts:

You may want to get close to a work to study a particular detail, but remember to be courteous to other visitors who may want to view the work at the same time. Never touch a work of art, because doing so can damage it. Do not take photos unless you are sure this is allowed. If in doubt, ask. Some museums permit visitors to take photos if flash is not used. Finally, although food and drink are not allowed in the exhibition spaces of museums and galleries, many have a café or restaurant.

Museum name	
Admission charge	
• Does the museum offer a reduced entry price for students?	
• Does the museum charge for entry to temporary exhibits?	
• Does the museum offer free or reduced admission prices on certain days?	
Opening hours	
Travel information	
• Does the museum charge for parking?	
Gallery rules	
• Are backpacks and cameras allowed in the galleries? If not, is there somewhere to check these? Is there a charge?	

Looking at Art

Visual Analysis

A work of art is the product of the dynamic interrelationships between the various art **elements** and **principles** as they are utilized by the artist. As you engage with a work of art, ask yourself why the artist made such choices. By looking more closely at artworks and trying to identify the elements and principles of art that have been used to create them, we may further understand the artist's intended vision and will notice how the artwork often reflects the time and place from which it came.

Line

How does the artist use **line** in your chosen artwork? Consider the following:

- **Actual** and **implied** lines (**2**)
- What do the lines communicate (**3**)?
- Are the lines regular or irregular?
- Do the lines express any emotions?
- Do the lines direct your eye through the work?

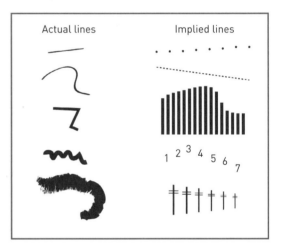

2 (above, right) Actual and implied lines

3 (right) Communicative qualities of line

Vertical lines communicate strength, stability, and authority

Horizontal lines communicate calm, peace, and passiveness

Diagonal lines communicate movement, action, and drama

Shape

How does the artist use **shape**? Consider the following:

- **Geometric** and **organic** shapes (**4**)
- Implied shapes (**5**)
- **Positive** and **negative** shapes (**6**)

4 Geometric and organic shapes

5 Implied shapes

6 Positive and negative shapes are created using the principle of contrast. Combining the two creates figure–ground reversal. The background can become the figure, and the figure can become the background.

NOTES AND SKETCHES

If the work is **three-dimensional**, consider the following:

Form

Did the artist choose geometric or organic form, or a combination of both?

Why do you think the artist made such choices?

Is the work a freestanding one that can be viewed from all sides ("**in the round**")?

If the work is a sculpture, is it carved with very little depth ("**bas-relief**"), or is it a carved panel where the figures project with a great deal of depth from the background ("**high relief**")?

Volume and Mass

Has the artist used **volume** or **mass** (**7**) to express any feelings or to communicate any ideas? Is the work's volume closed or open (**8**)?

Texture

Does the work have any actual texture, or is its **texture** only **implied**, that is, experienced solely from our memory of how the surface shown in the work would feel?

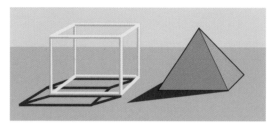

7 Volume and mass

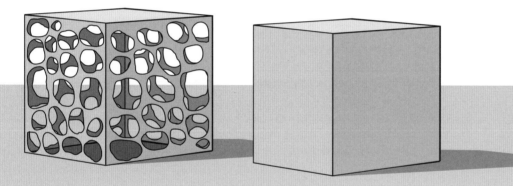

8 Open and closed volume
An open volume is when a space is enclosed by, but not made up of, solid material.

NOTES AND SKETCHES

There are various ways in which an artist can create the impression of three-dimensionality even in **two-dimensional** works, such as paintings and drawings.

Value

Are there any significant **value** changes (i.e. changes in the degrees of lightness and darkness) in the work? If so, why did the artist use value in this way (**9** & **10**)?

Does the artist use **hatching** or **cross-hatching** to create value (**11**)?

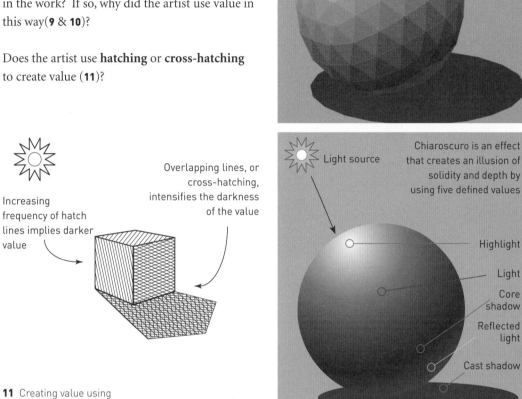

9 Values and planes of a geodesic sphere, vector graphic

Light source

Triangular planes make up the surface of this geodesic sphere. Each of these planes is illuminated differently depending on its location in relation to the light source

Plane

10 Diagram of chiaroscuro

Light source

Chiaroscuro is an effect that creates an illusion of solidity and depth by using five defined values

Highlight

Light

Core shadow

Reflected light

Cast shadow

Increasing frequency of hatch lines implies darker value

Overlapping lines, or cross-hatching, intensifies the darkness of the value

11 Creating value using hatching and cross-hatching

NOTES AND SKETCHES

Depth

Consider any techniques the artist uses to create a sense of depth in two dimensions.
For example:

- Size, overlapping, and position.
- Alternating value and texture.
- Brightness and color.
- Use of **atmospheric perspective** (**12**).
- **Isometric** perspective (**13**).
- **Linear** perspective (**14**).

12 The effects of atmospheric perspective

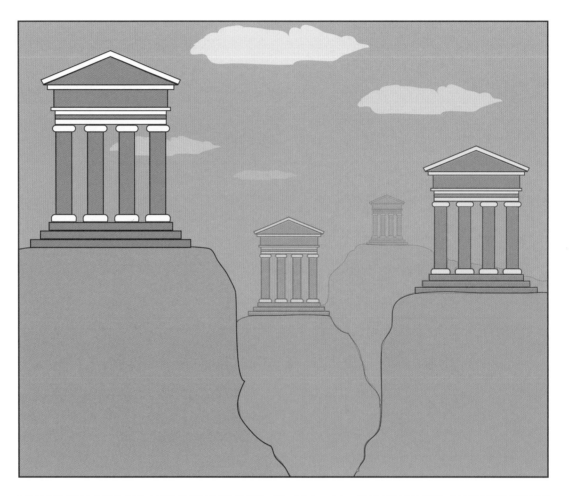

13 Graphic detailing isometric perspective

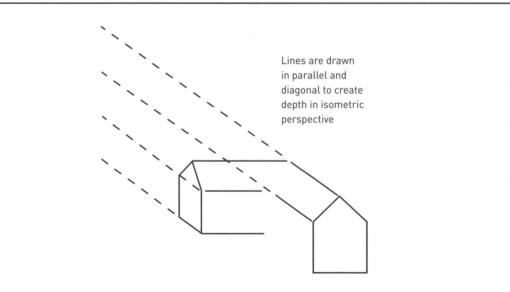

Lines are drawn in parallel and diagonal to create depth in isometric perspective

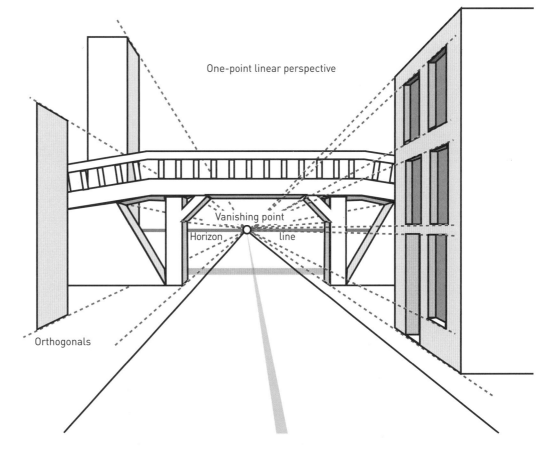

One-point linear perspective

Vanishing point

Horizon line

Orthogonals

NOTES AND SKETCHES

Color

Color is an important element of many artworks. Look carefully at the ways in which the artist uses color, for example:

Refer to the color wheel and note what **hues** the artist uses. Is the artwork **monochromatic** or does it use many hues (**15**)?

Does the artist use light **tints** of a color or darker **shades**, or a combination (**16**)?

Are the colors **saturated** (**17**)?

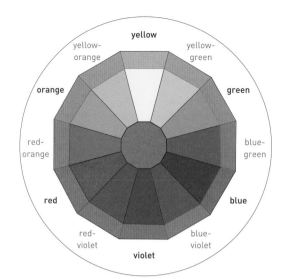

15 Traditional twelve-step color wheel using "artist's colors"

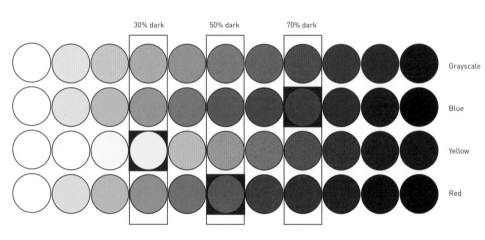

16 Color–value relationships

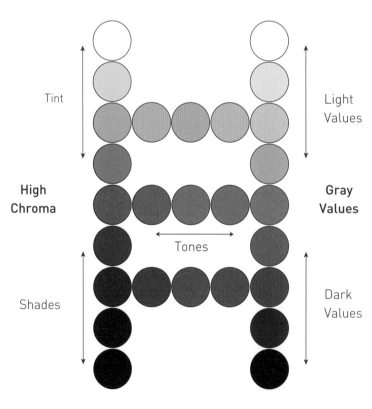

17 A sampling of chroma, tone, shades, and tints in red hue

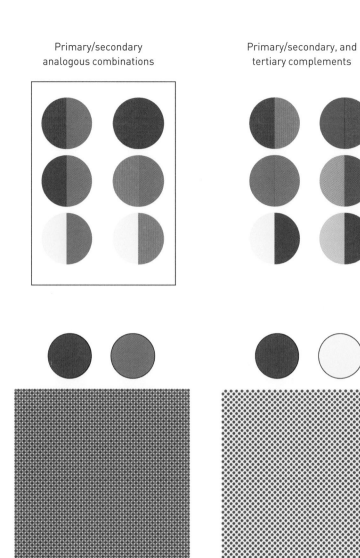

Primary/secondary analogous combinations

Primary/secondary, and tertiary complements

Examine the use of colors to see whether they are **analogous** or **complementary** colors (**18**).
Are the colors warm or cool?

Do you notice any visual effects, such as optical color mixing (**19**)?

Finally, think about the psychological and expressive effects of color in the artwork.
Do the colors elicit an emotional response from the viewer, or express the emotions of the artist?

18 (top, left) Color combinations and complements in pigment

19 (left) Two squares, one filled with red and blue dots and the other with red and yellow dots to create optical color-mixing effect

NOTES AND SKETCHES

Time and Motion

Does the artwork in some way communicate the passage of time? For example, it may tell a story or narrate a series of events. If the artwork you have chosen is in such a **medium** as film or video, the passage of time may be an important aspect of the artwork, but even static artworks can involve the passage of time.

Now consider whether the artwork involves **motion** in any way. Remember that even a static artwork, such as a painting, drawing or sculpture, can express motion.

If the work is static, is motion implied, or does the work convey an illusion of motion?

If your chosen artwork is a film or video, it will involve stroboscopic motion. This is when, as we are shown two or more repeated images in quick succession, they seem to fuse together as we watch.

Finally, consider whether the work involves actual motion (in other words, is it a **kinetic** work of art)? Notice any moving parts and ask yourself why the artist chose motion as a significant aspect of the work.

NOTES AND SKETCHES

Unity

Does the artwork express a carefully controlled order or wholeness (i.e., did the artist express **unity** in the work), or, in contrast, is it disordered or even chaotic (intentionally lacking in unity) (**20**)?

Consider aspects of the work that express unity (or its opposite, disunity). For example, are similar aspects of the composition repeated throughout to create visual harmony (**21**)?

Even though the **composition** may not appear unified, are there any conceptual aspects of the work that give it unity? For example, do its different aspects all relate to an overall idea or emotion, such as liberty, justice, or happiness?

Is the artwork an example of gestalt unity: in other words, do the composition and the ideas it expresses combine to make the whole work seem greater than the sum of its parts?

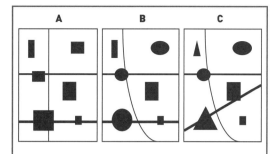

A This composition is unified, but lacks the visual interest of B

B Although there are several different shapes and planes in this composition, it is well balanced across the three parts marked by the horizontal straight lines

C This is a unified work, but its visual variety makes it feel incoherent and chaotic

20 (left) Three diagrams of compositional unity

21 (below) Katsushika Hokusai, "The Great Wave off Shore at Kanagawa," from *Thirty-Six Views of Mount Fuji*, 1826–33 (printed later). Print, color woodcut. Library of Congress, Washington, D.C.
A Mount Fuji almost blends into the ocean
B Whitecaps on the waves mimic the snow on Mount Fuji, creating a sense of the mountain's presence throughout the scene
C Solid shape of the great wave curves around the deep trough below it, uniting the two areas

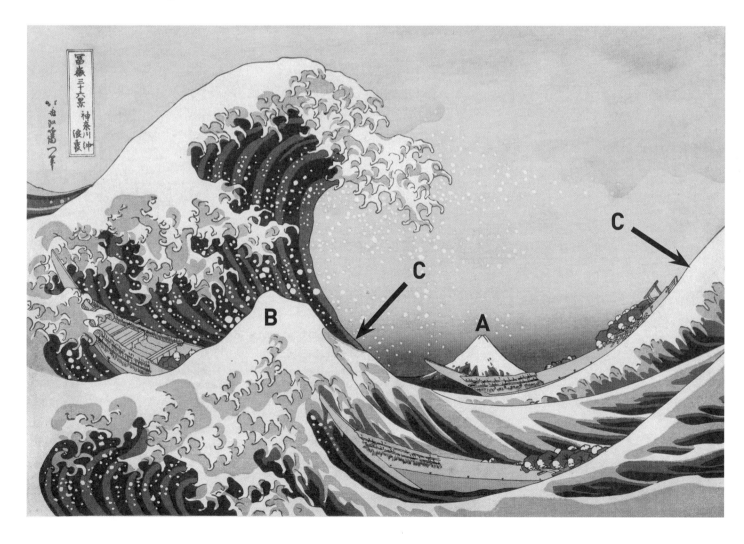

Variety

What aspects of the artwork give it **variety** (**22**)?

Consider value, texture, color, shape, and other elements of art.

What effect does the variety have on the viewer: does it suggest unity or a lack of unity?

22 Variety of shapes and values set into a grid

NOTES AND SKETCHES

Balance

Examine the artwork for any elements that give it **balance**: are the same or similar elements repeated throughout the work, or do elements of similar visual weight balance one another out? It will be helpful to see if you can detect symmetrical, asymmetrical, or radial balance.

To determine whether the artwork is symmetrically balanced, imagine that a line divides it horizontally or vertically into two equal parts. Can you see any elements that are repeated on both sides of the line?

If the artwork is not symmetrically balanced, it may be that the artist used elements of different visual weight to achieve balance. For example, is a large figure or object on one side of an imaginary dividing line balanced by several smaller figures or objects on the other side?

Another possible kind of balance is radial balance (or symmetry). The garden at the Taj Mahal is planned in such a way that each design element is repeated equidistant from a central point, giving a sense of harmony and perfection (**23**).

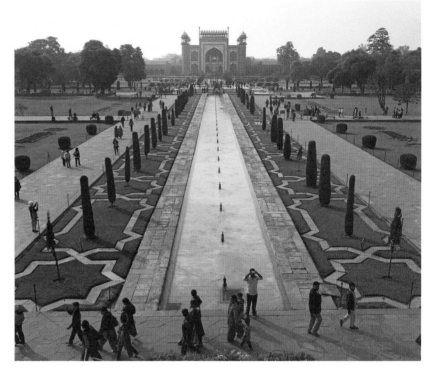

23 Mughal gardens and the South Gate of the Taj Mahal, Agra, India

NOTES AND SKETCHES

Scale

Whether the artwork is three-dimensional or in two dimensions, the artist may have chosen to create on a large **scale** or, alternatively, on a small scale. Did the artist make such a choice when creating the artwork you are studying? If so, why?

Are any figures or objects in the work larger than others, and if so, why?

NOTES AND SKETCHES

Proportion

Now, in addition to considering the overall scale of the work, consider the relative size (the **proportion**) of its parts (**24**). For example, if the figure is human, is the head unusually large, or are the arms abnormally long? Or is an object that is small in reality presented as larger than usual in the artwork?

24 Examples of how proportion changes on vertical and horizontal axes.
A: the original form;
B: when the width is reduced, the vase seems elegant and light;
C: reducing the height makes the vase seem clumsier and weightier

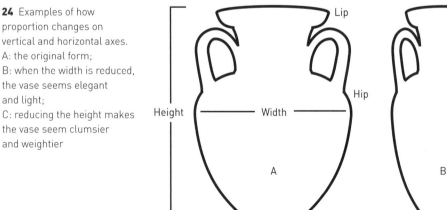

The Golden Section and the Golden Rectangles

The **Golden Section** (also referred to as the Golden Mean or Golden Ratio), is a proportional ratio of 1:1.618, which occurs in many natural objects and gives naturalistic results when applied to statues.

Artists have learned to apply proportional formulas to organize their compositions and ensure that their work is visually interesting. One such technique is known as "Golden Rectangles," because it is based on nesting inside each other a succession of rectangles based on the 1:1.618 proportions of the Golden Section. The shorter side of the outer rectangle becomes the longer side of the smaller rectangle inside it, and so on. The result is an elegant spiral shape.

See *Gateways to Art*, 2e, pp. 150–54 for more on this topic.

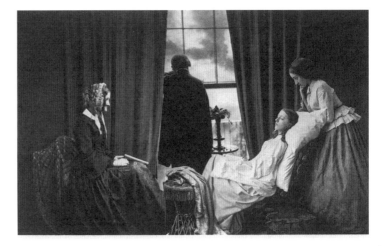

26 Henry Peach Robinson, *Fading Away*, 1858. Combination albumen print. George Eastman House, Rochester, New York

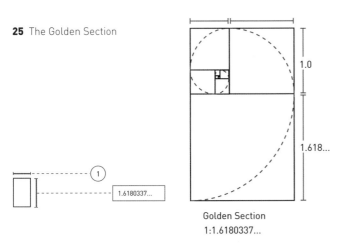

25 The Golden Section

Golden Section
1:1.6180337...

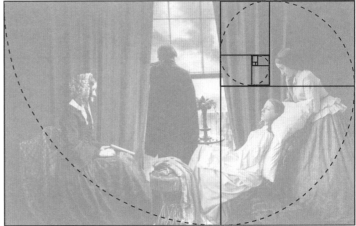

27 Proportional analysis of the photograph

NOTES AND SKETCHES

Emphasis, Focal Point, and Subordination

Has the artist used any elements of the artwork to draw attention to particular parts or aspects of the work ("**emphasis**")?

Or, on the other hand, has the artist drawn attention away from particular parts or aspects of the work ("**subordination**")?

Why do you think the artist did this? Does the artwork have a **focal point** or points (a specific part or area of the work to which the artist draws the viewer's eye)? How does the artist direct the viewer's eye to the focal point? For example, does the artist use line, contrast, placement, or some other method?

Bruegel's painting *Landscape with the Fall of Icarus* (**28**) illustrates a story from Greek mythology. Daedalus and his son Icarus are imprisoned on the island of Crete by the ruler, Minos. They try to escape using homemade wings, but Icarus flies too close to the sun and the wax attaching his wings melts, causing him to fall and drown.

When we look at the artwork, our attention is drawn first to the figure in the red smock, who plows his field, unaware of the tragedy. Next we might notice the tree on the left or the large ship on the right. It is easy to miss poor Icarus drowning in front of the large ship, his feet hardly distinguishable from the whitecaps and the tiny seabirds circling near the vessel.

Bruegel has gone to such lengths to draw attention away from the plight of his subject that art historians think this painting may be an illustration of the Flemish proverb, "No plough stands still because a man dies." Or, as we might say, "Life goes on." Either way, it is a brilliant example of using emphasis and subordination to direct and control the way in which the viewer perceives the painting.

28 Pieter Bruegel the Elder, *Landscape with the Fall of Icarus*, c. 1555–8. Oil on canvas, mounted on wood, 29 × 44⅛". Musées Royaux des Beaux-Arts de Belgique, Brussels, Belgium

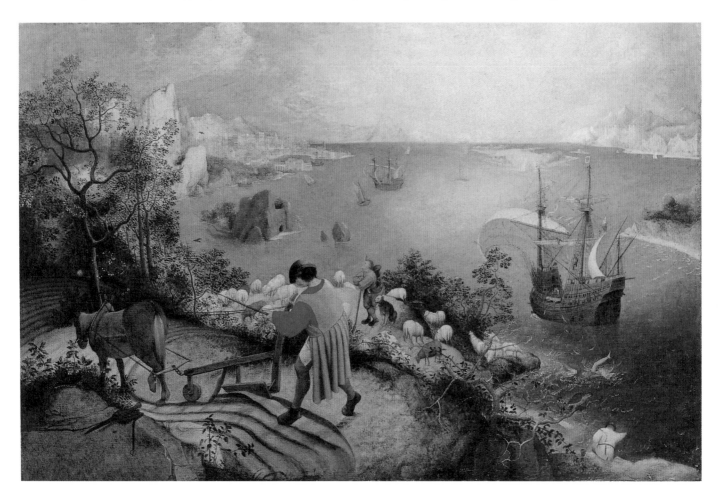

Pattern

Can you identify any repetition of an element (such as shape, value, or color) in the artwork that creates a **pattern** (**29**)?

Can you think of any reasons why the artist chose to create such patterns?

A design repeated as a unit is called a motif. Can you identify any motifs in the work? For example, repetition of a flower, of leaves, or of an animal is a motif, as is repetition of a geometrical design.

Rhythm

Rhythm is the ordered or regular repetition of elements in a work. Can you identify any elements in the artwork that create rhythm?

Identify the type of rhythm used: is it simple repetitive rhythm, progressive rhythm, or alternating rhythm (see *Gateways to Art*, 2e, pp. 171–75)?

29 Horizontal alternating pattern

Rhythm can also be achieved by the ordered or regular division of space in a work. Has the artist divided space within the composition in a way that creates a rhythmic design?

NOTES AND SKETCHES

Media

Now that you have completed your visual analysis of the artwork, this is a good time to think about the artist's materials (in other words the media that the artist chose) and the methods used to create the work. Think about why the artist chose a particular medium: did it make it possible, for example, to create a large work because the material is strong, or did a particular medium give the work a specific color or texture? Did the medium impose any limits on the artist?

Some media that you might encounter are:

Drawing

Consider the materials utilized: pencil, silverpoint, chalk, charcoal, crayon, pastel, ink, wash. Was the artist able to make controlled strokes with this medium? Would the tool used create a thick or thin line? One that was defined, or blurred? Was the drawing intended to be a work of art in itself? Or is it a study for another work, a peek into the artist's creative process?

Painting

How did the type of paint affect the brushstrokes the artist could make? Was it fresco, oil, tempera, watercolor, encaustic, acrylic, or some other type of paint? Was it a fast-drying paint, giving the artist little time to make changes? What kind of textures and lines was the artist able to create with this medium? Does it create a shiny or flat look? How durable was the medium? How was the paint applied to the surface: with a brush, a palette knife, dripped, or sprayed?

Printmaking

What is the process the artist undertook to create this work? Was it relief (a surface was carved to create a raised image; **30**), intaglio (the artist cut into a surface to create the image; **31**), or planographic (the print was made from an entirely flat surface; **32**)? Did the artist need to engrave or etch? Did the artist use lithography or silkscreen printing? Strength or patience?

30 (below) A brief overview of the relief printing process:

1 An image is designed and is prepared for transfer to the block surface.
2 The image is now transferred to the block.
3 The surface area that will not be printed is carved away.
4 The remaining protruding surface is carefully inked.
5 The raised inked area is transferred to the surface to be printed.

31 (right) A brief overview of the engraving process (intaglio)

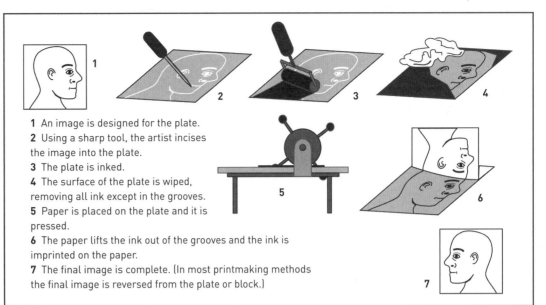

1 An image is designed for the plate.
2 Using a sharp tool, the artist incises the image into the plate.
3 The plate is inked.
4 The surface of the plate is wiped, removing all ink except in the grooves.
5 Paper is placed on the plate and it is pressed.
6 The paper lifts the ink out of the grooves and the ink is imprinted on the paper.
7 The final image is complete. (In most printmaking methods the final image is reversed from the plate or block.)

32 (below) A brief overview of the lithography process:
1 The artist designs the image to be printed.
2 Using a grease pencil, the design is drawn onto the limestone, blocking the pores.
3 The stone is treated with acid and other chemicals that are brushed onto its surface. Then the surface is wiped clean with a solvent, such as kerosene.
4 The stone is sponged so that water can be absorbed into the pores of the stone.
5 Oil-based ink is repelled by the water and sits only on areas where the oil crayon image was drawn.
6 Paper is laid on the surface of the stone and it is drawn through a press.
7 The print is removed from the stone.
8 The completed image appears in reverse compared with the original design.

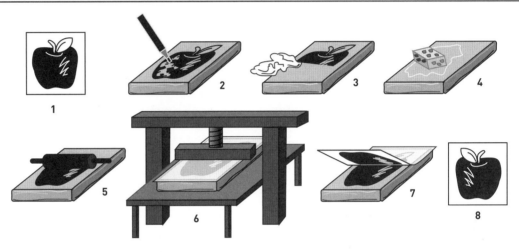

NOTES AND SKETCHES

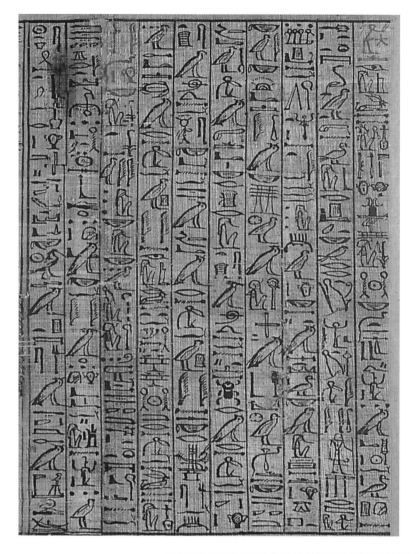

Visual communication design (also known as graphic design)

What format has the designer chosen (poster, book, advertisement, etc.)? Is the work color or black and white? How does the artwork combine text and images? What kinds of typefaces has the artist selected? What information or ideas do you think the designer intended to communicate (**33**; **34**; **35**; **36**)? See if the museum or gallery you are visiting holds other works that are forms of visual communication design.

33 (left) Section of papyrus from *Book of the Dead of Ani*, c. 1250 BCE. British Museum, London, England

34 (right) Albrecht Dürer, pages from *Course in the Art of Measurement with Compass and Ruler*, 1538. Victoria and Albert Museum, London, England

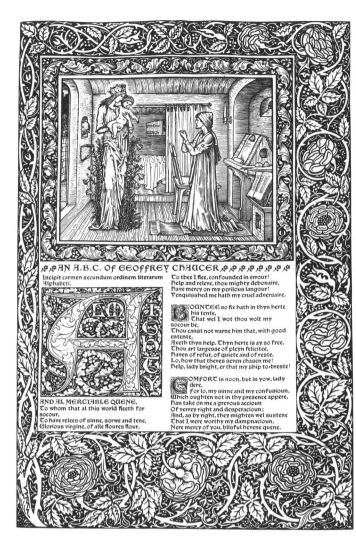

35 William Morris and Edward Burne-Jones, page from *Works of Geoffrey Chaucer*, Kelmscott Press, 1896. British Museum, London, England

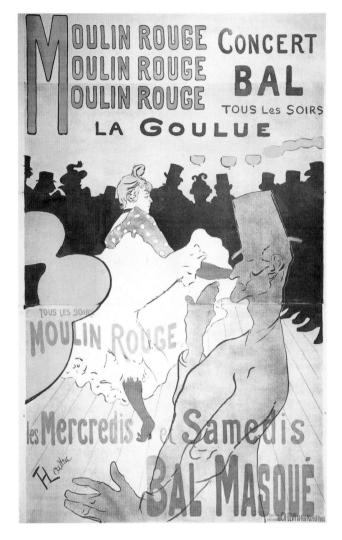

36 Henri de Toulouse-Lautrec, *La Goulue at the Moulin Rouge*, 1891. Lithograph in black, yellow, red, and blue on three sheets of tan wove paper, 6'2½" × 3'9⅝". Art Institute of Chicago

NOTES AND SKETCHES

Sculpture

Is the sculpture in high or low relief, or can we see the object in the round? What challenges did the material present to the artist? Is the sculpture an installation or environment that we can enter or experience? Was the object created through a subtractive process (beginning with a large mass of the medium and taking away from it to create form) or an additive process (in which sculptors add material to make the final artwork; **37**)? What tools did the artist use to create the form? If the form is human, is the artwork life-size? Was the sculpture made by appropriating or adapting an everyday object (a found object)?

Architecture

Does the building represent the work of a community or the power of a leader? How was it constructed (**38**; **39**)? What was the structure's intended use? How does it fit with its surroundings? Is it a domineering or welcoming structure?

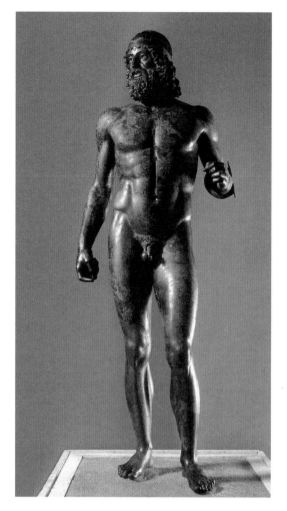

37 Riace Warrior A, *c. 460* BCE. Bronze with copper, silver and ivory, 6'6" high. Museo Nazionale della Magna Grecia, Reggio di Calabria, Italy

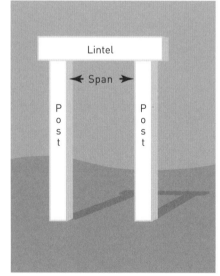

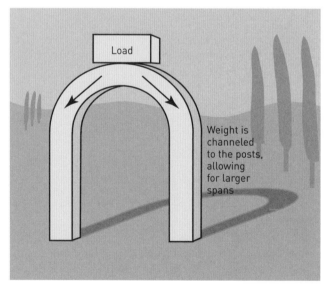

38 Post-and-lintel construction

39 Arch construction

Traditional "Craft" Media

Is the work made of ceramics, glass, metal, fiber, wood, or some other material (perhaps a modern synthetic material, or an everyday object)? Why do you think the artist chose a particular material: is it strong and durable, is it flexible, does it have a particular texture?

Photography

Was the photograph taken using film or was it taken using a digital camera? Is it in color or black and white? Does it appear to have been manipulated in any way? What is the subject matter: is this a portrait, a still life, a photograph that documents a real event; does it in some way express an artistic idea?

Photocollage/collage

Has the work of art been assembled by gluing materials, often paper, but also photographs, for example, onto a surface? What do you think the artist intended by making a collage?

Film or video

Is the film or video in color or black and white? Is it silent or is there sound? Is it shown on a small screen or projected on to a large one? Is it shown in an enclosed space or in a gallery alongside other works?

Conceptual art

Does the work emphasize ideas and downplay its aspect as a craft object? If so, what ideas does the artist communicate?

NOTES AND SKETCHES

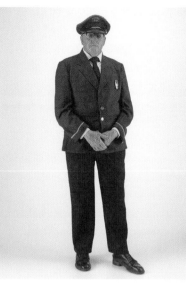

40 Duane Hanson, *Museum Guard*, 1975. Polyester, fiberglass, oil, and vinyl, 69 x 21 x 13". The Nelson-Atkins Museum of Art, Kansas City, Missouri

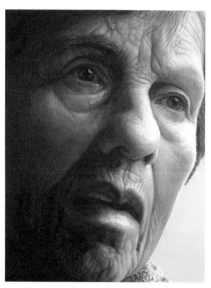

41 Cindy Wright, *Moe*, 2005. Oil on canvas, 67 x 51¼"

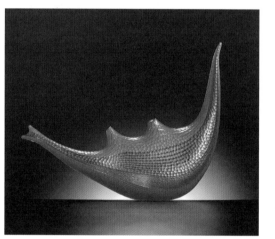

42 Lino Tagliapietra, *Batman*, 1998. Glass, 15½" × 3½"

Artworks communicate visual ideas, just as spoken and written language communicate visual ideas. As well as considering the visual language of a work (what is known as "visual analysis") and the media used to create it, we must also consider what the artist wanted to communicate: the work's content.

Representational, Non-Objective, Abstract

As a first step in considering the content of a work, decide whether it is representational or non-objective. A representational work depicts objects or people in such a way that we can recognize them (**40** & **41**). A non-objective work depicts subject matter that is not recognizable as an object or people (**42**).

Both representational and non-objective art can, to some degree, be abstract. Abstract means literally to extract something or to emphasize it. In art this means that artists can emphasize, distort, simplify, or exaggerate the formal (visual) elements of a work. Has the artwork you are studying been abstracted, and to what degree? Is the thing it represents still recognizable to some extent?

NOTES AND SKETCHES

Modes of Analysis

There is no single "right way" to analyze a work of art. We are often able, however, to find out more about a work than we can learn from only visual analysis and a consideration of the medium used. There are several other methods we can use to interpret a work, and these can often be combined. Based on what you can tell from looking at the work, by studying the gallery or museum label, and by applying any background knowledge you have, you can take your analysis of your chosen work further.

Ask yourself whether you can apply any of the following methods to it:

Formal analysis

Formal analysis involves looking closely and in detail at the work in order to consider how the formal elements and principles of art are used to create it and to convey meaning.

Stylistic analysis

Stylistic analysis focuses on the characteristics that make a work of art distinctive in order to identify how they typify the work of an individual, are shared by a group of artists to create a movement, or are concentrated in a particular place or time period.

Iconographic analysis

Iconographic analysis interprets objects and figures in the artwork as signs or symbols, often based on religious or historical contexts that would have been fully understood at the time it was made.

Contextual analysis

Contextual analysis looks at the making and viewing of the work in its context (historical, religious, political, economic, and social); it studies the context that the artwork itself represents.

Biographical analysis

Biographical analysis considers whether the artist's personal experiences and opinions may have affected the making or meaning of the artwork in some way.

Feminist analysis

Feminist analysis considers the role of women in an artwork as its subjects, creators, patrons, and viewers; it explores ways in which the work reflects the experience of women.

Gender Studies analysis

Gender Studies analysis expands the considerations raised by feminist analysis to explore ways in which the work reflects experience based on a person's gender.

Psychological analysis

Psychological analysis investigates an artwork through interpretation of the mental state of the artist when he or she created the work.

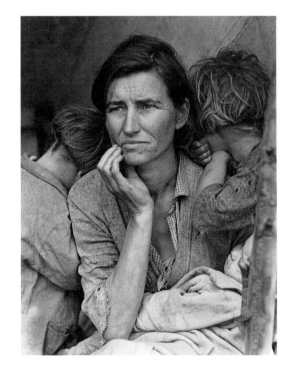

43 (right) Dorothea Lange, *Migrant Mother*, 1936. Library of Congress, Washington, D.C.

This photograph became a symbol of the hardships of the Great Depression. You could therefore analyze it in an iconographic way, as well as using contextual analysis. Because it depicts a mother with her children, see also what you discover if you use feminist analysis to explore its meanings.

History

Consider the room in which your chosen work of art is located in the museum. Does the museum display works from a particular era or century in the same room? Are works organized by culture (American, Chinese, etc.)? Is the work you are studying displayed with works from a particular locality (your state or city, for example)? Is it displayed with other works by the same artist, or by a group of artists who worked together and created works in a similar style (for example, **Impressionist**)? The arrangement of works in the rooms of the museum, together with the information provided on the work's label, will usually help you learn something about the historical context in which the artwork was created.

Make notes and consider what this information suggests about the reasons why the artist created the work, and the way it is designed.

The artworks below are considered to be in the Impressionist style, which rejected the formal realism of the earlier nineteenth century, seeking instead to capture the light and sensations of everyday life. Impressionist artists often painted outdoors in a sketchy, spontaneous way that resulted in visible brushstrokes, such as those you see in **44** and **45**.

44 (left) Monet, *Varengeville Church*, 1882. Barber Institute of Fine Arts, Birmingham, UK

45 (right) Pissarro, *Hoarfrost*, 1873 Oil on canvas, 25⅝ × 36⅝". Musée d'Orsay, Paris, France

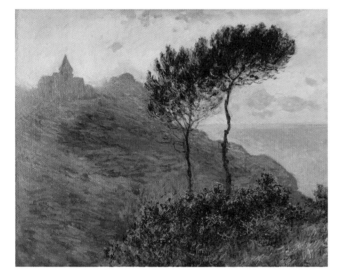

NOTES AND SKETCHES

Theme

Artworks usually communicate something to the viewer (for example, an idea or an emotion). Many works express to us something about important themes that have interested artists for many centuries. Consider whether the work you are studying tells you anything about one of the following themes:

- The community that created it
- Spiritual or religious beliefs
- The cycle of life (birth, family, age, death, the afterlife, nature)
- Science and technology
- Illusion or trickery
- The power of rulers or of others in authority
- War and conflict
- Social protest and issues
- The body
- Gender
- An expression of the artist's own personality or opinions.

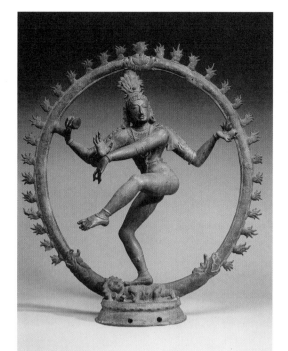

46 *Shiva Nataraja* (*Lord of the Dance*), Chola Period, 11th century. Bronze, 43⅞" high. Cleveland Museum of Art, Ohio

This sculpture of a Hindu deity expresses religious beliefs and also the theme of the endless cycle of birth and death that we experience in life.

NOTES AND SKETCHES

Summary of Visual Analysis

On this page, make notes of what you think are the most important things you have learned about the artwork from your visual analysis, from considering its media, and from analyzing its content. Try to suggest what the artist was seeking to communicate, and support your conclusion with evidence from your analysis. If the museum or gallery that you visited displays other works by the same artist, or works that are from the same period or depict the same subject matter, compare them with the work you chose to study. Note briefly any similarities or differences.

NOTES AND SKETCHES

Understanding What Museums Do

Visiting a museum is a great way to boost your knowledge of art history. You can learn about your local heritage and that of other cultures. In this section, we take a look behind the scenes at a selection of museums across North America. Learning about these museums will assist you in discovering the services that may be available in your own museum and shed new light on the varied functions that museums fulfill in your community. Understanding what museums do will also help you to complete your assignment. Make sure you are clear about what is being asked of you, and do the research involved either online, or during your museum visit.

47 Philadelphia Museum of Art, Pennsylvania

Museums Evolve over Time

48 Dale Chihuly's *Niijima Floats* sculptures (1992) in the Glass Pavilion, Toledo Museum of Art, Ohio

Toledo Museum of Art, OH

The three buildings of the Toledo Museum of Art can tell us a lot about how the museum has evolved over time. Each one was built at a different point in the museum's history and in a distinct architectural style.

The first, built when the museum was founded in 1901, is **Classical**, with **Ionic** columns on the facade. At that time, its sober, traditional appearance was thought appropriate for an important civic institution.

The second building, built to house the museum library and an art school, is a bold metal-and-glass design from 1992, created by the prominent architect Frank O. Gehry (b. 1929).

The glass industry is an important part of Toledo's history, and the museum owns a renowned collection of glass art. This is reflected in the choice of materials in the third building, the Glass Pavilion, designed in 2006 by Japanese architects Kazuyo Sejima (b. 1956) and Ryue Nishizawa (b. 1966), which was created specifically to house the glass collection.

We can see from the development of the Toledo museum site that a lot of thought goes into the buildings art is displayed in, whether they are made to stand out from or harmonize with their surroundings, in order to create an inspiring environment for the visitor.

■ Consider the design of the museum you have chosen to visit. What style is it built in (e.g. Classical, modern, Brutalist, Postmodern)? Does the style of the building relate to the type of art on display inside? How do the light and space in your museum affect your perception of the works of art?

■ How do visitors enter the museum – through multiple entry points or one main entrance? What is the layout of the museum like – are visitors encouraged to wander and view the objects in any order, or do they follow a set route from exhibit to exhibit?

NOTES AND SKETCHES

High Museum of Art, Atlanta, GA

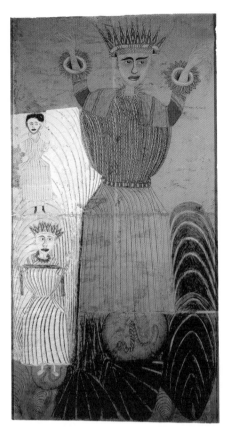

49 Martín Ramírez, *Untitled (La Inmaculada)*, 1950s. Crayon, pencil, watercolor, and collaged papers, 7'8" × 3'9". High Museum of Art, Atlanta, Georgia

Like the Toledo Museum of Art, the High Museum has altered over time. The museum started life in the High family home in 1905 before moving to a purpose-built space in 1983. Architect Richard Meier (b. 1934) designed a light and airy building to reflect the atmosphere of enlightenment that many people find in museums.

As well as external changes to their buildings, museums evolve by updating and expanding their collections in response to the latest views on art. In 1996, the High was the first museum in the world to establish a dedicated department for **folk** and **self-taught** art, including works by such Southern artists as Bill Traylor and Sam Doyle, as well as the Mexican-born Martin Ramirez (**49**) and Joseph Yoakum, who is of mixed African-American and Native American descent.

Although museums take strict measures to protect objects from the past, they are not always rigid about keeping traditional ideas intact. In this case, the High Museum was the first to re-evaluate the significance of artworks that were previously not thought to be important enough to be exhibited.

■ How has the permanent collection at your museum evolved over time? Did it begin life as the private property of a prominent collector or family? If so, what kind of art did the family or individual originally collect?

FINAL TASK
Do some research online about your museum's origins, and describe how both the building and its collection have changed over the years. If your museum has only recently opened, do some research and find out if it has any particular aims or areas in which it intends to specialize.

NOTES AND SKETCHES

Museums Preserve Our Heritage

The Museum of Fine Arts, Houston, TX

50 Frederic Remington, *Aiding a Comrade*, 1889–90. Oil on canvas, 34⁵/₁₆ x 48¹/₈". Museum of Fine Arts, Houston, Texas

Every museum collection represents a portion of humanity's artistic **heritage**, the objects and traditions we value. Artworks in local museums also teach us about our regional heritage.

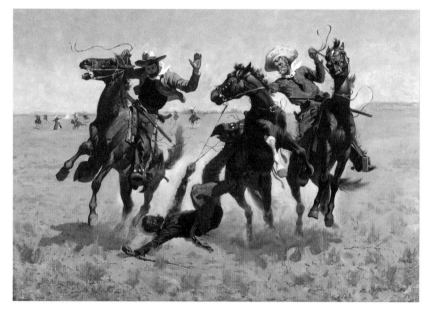

The Museum of Fine Arts, Houston has a fine selection of art from many eras and cultures. It provides an insight into the heritage of Western art, with works by such European masters as Peter Paul Rubens (1577–1640), Albrecht Dürer (1471–1528), and Thomas Gainsborough (1727–1788).

On a national level, the museum's Bayou Bend annex has an excellent collection of American **decorative arts**, works of art designed for both utility and visual appeal, including furniture, textiles, and metalwork, with each room specially designed to match the objects displayed in it.

Finally, a noteworthy collection of Frederic Remington's (1861–1909) paintings of cowboys on the Western frontier brings the city of Houston's nineteenth-century frontier past to life for its modern inhabitants, giving them a sense of their local heritage (**50**).

■ Is your region known for any folk or decorative art traditions, or any famous artists that were born or worked there?
■ Does your museum feature artworks that highlight your local or personal heritage? If so, which ones, and what is their connection to your region or country?

NOTES AND SKETCHES

The Tucson Museum of Art, AZ

The collection at the Tucson Museum of Art, similarly to that at the Houston museum, includes some Western art, but also features art that reflects Arizona's rich local heritage. One part of the collection explores links to Native American culture (twenty-two tribes live in the state today), including works that show combined Native American and Euro-American influences, demonstrating the impact of cultural exchange over time.

The museum's collection of Pre-Columbian art of the Americas presents a wide range of the ancient artistic traditions of the continent, as well as art of the Portuguese and Spanish colonies in the Americas (Arizona was, of course, once a Spanish colony and was part of independent Mexico until 1848).

■ Think about the artworks on display at your museum. What cultures do they represent?
■ Are there any "crafts" of native and tribal cultures, such as textiles or pottery, and if so, are they displayed in a different way to the other art? Does displaying them as art in glass cases make it more difficult to understand how they were used or worn?
■ Should "crafts" be placed beside objects generally accepted as "art," such as paintings and sculpture, or should they be exhibited separately? Why, or why not?

NOTES AND SKETCHES

Museums Shape Our Experience of Art

The Museum of Modern Art, NY

Art history does not just happen: our view of how art has developed over time has been shaped by scholars, critics, and by museums and their **curators**. Some museums have played an especially important role in this regard: the Museum of Modern Art (MoMA) in New York is one of the most influential museums in the world.

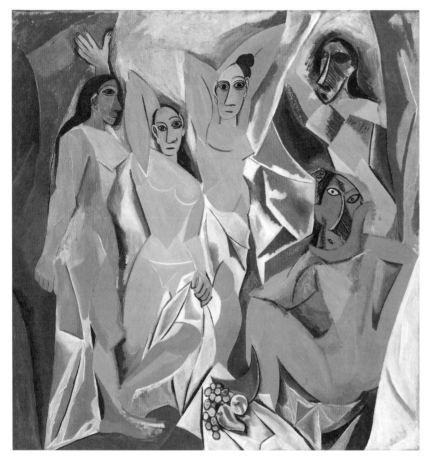

Since its foundation in 1929, MoMA has shaped the history of modern art in several ways. Its curators choose which artworks from the collection to display, and how these should be presented. The information labels on the wall and the position and order of the artworks in each gallery represent a narrative told to the visitors by the curators.

As well as selecting objects for the museum's permanent collection, curators organize **temporary exhibits** and **retrospectives**, shows that take a look back at the work of a particular artist over a certain period of time.

In 1939–40, MoMA held a retrospective of the work of Pablo Picasso (1881–1973), when the artist was nearly sixty. By representing a wide range of his artworks across a variety of media and including some artworks that were on show for the first time, the museum reinterpreted Picasso's art and played an important part in establishing his reputation as the greatest artist of his time. In this way, the exhibit had an impact on the remainder of Picasso's career, as it meant that the public became more informed and enthusiastic about his work.

51 Pablo Picasso, *Les Demoiselles d'Avignon*, 1907. Oil on canvas, 8' ×7'8". MoMA, New York

Even if it is not possible for you to visit MoMA, you can still experience some of the most important works in this world-class museum by accessing the video resources that accompany *Gateways to Art*, 2e. In these videos, MoMA curators share fascinating insights about the most famous masterpieces from the collection, which features artworks by Pablo Picasso (1881–1973), Henri Matisse (1869–1954), and Vincent van Gogh (1853–1890).

■ Consider the permanent collection in your local museum. What kind of art do you think the curators consider to be most important, and why? How have they organized the collection: think about which artworks are displayed together and whether any are given special prominence.

FINAL TASK
What are some of the major temporary exhibits or retrospectives your museum has hosted? Why were they important and how did they tell the public something new about the art on display?

NOTES AND SKETCHES

Portland Art Museum, OR

We often hear about museums acquiring a particularly important artwork, but it is rare for a museum to be able to add to its holdings an entire collection of art that documents the important artists of an era. In 2000, the Portland Art Museum was fortunate enough to acquire the collection of the influential art critic Clement Greenberg (1909–1994).

Greenberg was a critic who championed **avant-garde** American art styles, such as **Abstract Expressionism**, and helped many artists to achieve international recognition. He was also an important influence in artists' studios, offering them advice on developing, cropping, and hanging their work.

Over a period of 50 years Greenberg collected 159 paintings, prints, drawings, and sculptures by some of the most prominent artists of the twentieth century, including, for example, 43 works by Kenneth Noland (1924–2010) from 1958 to 1981. The career of Jules Olitski (1922–2007) is documented by 23 works from 1965 to 1982. This collection provides viewers with the unique opportunity to study the development of these artists, to gain insights into the preoccupations of artists in Greenberg's time, and to evaluate each artist's work alongside that of his or her peers.

■ Does your museum include works that once belonged to an influential critic, a wealthy local citizen, or somebody else who succeeded in forming a significant collection of artworks? What can the collection tell you about the art of its era?

NOTES AND SKETCHES

The Indianapolis Museum of Art, IN

Unlike such major cities as New York, Chicago, or Los Angeles, regional cities do not have access to substantial financial resources when assembling their museum collections. For this reason, they often focus on building comprehensive collections in specific areas rather than trying to rival their larger counterparts. In this way, they provide their visitors with a sense of context that can enhance their understanding of the art on display.

52 Michael Graves, example of a 9093 kettle, 1985. Stainless steel and plastic, 8³/₄ x 8¹/₂". Indianapolis Museum of Art, Indiana

Although the collection of the Indianapolis Museum of Art (IMA) includes artworks from ancient to modern from every continent and across many media, it is the museum's contemporary design collection that is exceptional. It includes more than 400 works dating from about 1980, including furniture, metalwork, and domestic objects, such as typewriters and vacuum cleaners. Appliances and homewares designed by Michael Graves (1934–2015), a well-known architect born in Indianapolis, also feature in the collection (**52**).

A second area of strength at IMA is the collection of French paintings from the 1880s and 1890s. Visitors have the chance to make an in-depth comparison between two important late twentieth-century styles, the Pont-Aven school and the Neo-Impressionists, perhaps by considering a landscape by Emile Bernard (1868–1941) alongside one by Paul Signac (1863–1935).

■ **What are the strengths of your local museum? Is a famous local artist or designer represented in the collection? Can you study a particular form of art in depth (e.g. furniture or sculpture)? Can you compare the different styles of two artists of the same period?**

NOTES AND SKETCHES

Museums Reach out to the Public

The Birmingham Museum of Art, AL

There are many professionals in your museum who help visitors enjoy and understand the art on display. While curators are in charge of organizing exhibitions and providing information about the artworks, **docents** are trained to act as guides to the artworks on display. They are generally very knowledgeable about the collection, and can often help you identify what to look for when viewing an artwork, or explain why an artist might have chosen a particular medium or style.

The docents at the Birmingham Museum of Art in Alabama host a number of activities for all ages, from free family tours to the museum's Visually Impaired Program, in which those with vision difficulties can handle works of art, with the help of specially trained guides (**53**). Docents may also schedule lectures from art history professors and artists, as well as evening events and festivals, where visitors can view the art alongside concerts and performances.

- Does your museum offer any special tours, lectures, or events hosted by docents? Does the museum host any other sorts of event? Are these events free of charge? Does the museum have any free or reduced-fee days or hours?
- What sorts of media (such as movie screenings) and facilities (such as restaurants) are in place to attract visitors to the museum? How is the local or regional community involved in museum events?

53 Visitors examining a bronze sculpture as part of the Visually Impaired Program at the Birmingham Museum of Art, Alabama

NOTES AND SKETCHES

The J. Paul Getty Museum of Los Angeles, CA

Many museums also have an education department where **art educators** develop a wide range of programs and resources for a variety of audiences. The J. Paul Getty Museum is home to one of the pre-eminent education departments. As well as organizing activities and events for schoolchildren and adult learners, it hosts regular College Nights, with gallery tours led by a curator or **conservator** (a member of museum staff who is responsible for repairing the objects in the collection and preserving them for future visitors).

The Getty's outreach program also extends beyond the museum walls, as it has made thousands of high-resolution images of its collection available online; these are free to use, modify, and publish for any purpose and can be found at getty.edu/art. The Getty's YouTube video stream also hosts videos filmed at archaeological sites, artist's studio visits, and analyses of individual artworks.

■ Is there an education department at your museum? What sorts of programs does it run, and what kinds of audiences does it aim to reach?

■ Does your museum also have an online collection of its art? What other resources does your museum offer on its website? Can you think of other ways in which a museum could offer the public an enhanced experience of its collections?

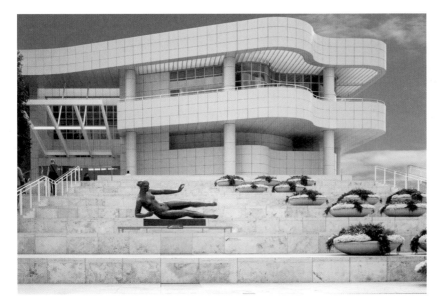

54 Richard Meier, The J. Paul Getty Museum of Los Angeles, California, 1997

NOTES AND SKETCHES

A Global Museum for a Global World

The Pérez Art Museum, Miami, FL

55 Herzog & de Meuron Ltd, The Pérez Art Museum, Miami, Florida, 2013

Most major cities in the USA have an important art museum, but until the end of the twentieth century, Miami did not. In fact, the Pérez Art Museum is so new that more than a quarter of the works in its collection were acquired in 2013.

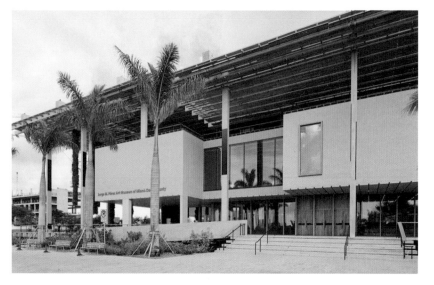

Miami's population includes many recently arrived immigrants, especially from the Caribbean and Latin America, and it is home to a vibrant artistic community. The Pérez Art Museum reflects the contemporary and international character of the city. Its collection features works by such artists as American Kehinde Wiley (b. 1977), Cuban Bedia Valdés (b. 1959), and Colombian Beatriz González (b. 1938).

The Pérez Art Museum is a vital part of the wider contemporary art scene in Miami. In December, the museum hosts a special exhibition to welcome visitors to the annual Art Basel Miami Beach, a modern and contemporary art fair that attracts artists, dealers, collectors, curators, critics, and art enthusiasts. The museum and the art fair have helped to make Miami a major center for contemporary global art.

■ Go online and research locations and events in your community, in addition to the local museum, where you can find art on display. Are there commercial galleries that are open for public view? Is there an art fair or a local association for the arts that organizes regular shows?

NOTES AND SKETCHES

Glossary

Abstract: art imagery that departs from recognizable images from the natural world

Abstract Expressionism: a mid-twentieth-century artistic style characterized by its capacity to convey intense emotions using non-representational images

Actual line: a continuous, uninterrupted line

Analogous colors: colors adjacent to each other on the color wheel

Art educators: people that work in the education department of a museum or gallery

Atmospheric perspective: use of shades of color and clarity to create the illusion of depth. Closer objects have warmer tones and clear outlines, while objects set further away are cooler and become hazy

Avant-garde: early twentieth-century emphasis on artistic innovation, which challenged accepted values, traditions, and techniques

Axis: an imaginary line showing the center of a shape, volume, or composition

Balance: a principle of art in which elements are used to create a symmetrical or asymmetrical sense of visual weight in an artwork

Bas-relief: a sculpture carved with very little depth

Classical: art that conforms to Greek and Roman models, or is based on rational construction and emotional equilibrium

Collage: a work of art assembled by gluing materials, often paper, onto a surface. From the French "coller," to glue

Color: the optical effect caused when reflected white light of the spectrum is divided into separate wavelengths

Complementary colors: colors opposite one another on the color wheel

Composition: the overall design or organization of a work

Conservator: a person who cares for, restores, and repairs the objects in a museum

Cross-hatching: the use of overlapping parallel lines to convey darkness or lightness

Curator: a person who organizes the collection and exhibition of objects/artworks in a museum or gallery

Decorative arts: Types of art that are concerned primarily with creation of such useful items as furniture, ceramics, and textiles

Docent: a person who leads guided tours around a museum or gallery

Elements: the basic vocabulary of art—line, form, shape, volume, mass, color, texture, space, time and motion, and value (lightness/darkness)

Emphasis: the principle of drawing attention to particular content within a work

Facade: any side of a building, usually the front or entrance

Focal point: the center of interest or activity in a work of art, often drawing the viewer's attention to the most important element

Folk art: the traditional, typically anonymous art of usually untrained people

Form: an object that can be defined in three dimensions (height, width, and depth)

Geometric shape: A shape composed of regular lines and curves

Golden Section: a unique ratio of a line divided into two parts so that a + b is to a as a is to b. The result is 1:1.618

Hatching: the use of non-overlapping parallel lines to convey darkness or lightness

Heritage: the traditions, achievements, and beliefs that are part of the history of a group or nation

High relief: a carved panel where the figures project with a great deal of depth from the background

Hue: general classification of a color; the distinctive characteristics of a color as seen in the visible spectrum, such as green or red

Implied line: a line not actually drawn but suggested by elements in the work

Implied texture: a visual illusion expressing texture

Impressionism: a late nineteenth-century painting style conveying the impression of the effects of light

Installation: an artwork created by the assembling and arrangement of objects within a specific location

Intensity: the relative clarity of color in its purest raw form, demonstrated through luminous or muted variations

In the round: a freestanding sculpted work that can be viewed from all sides

Ionic: of or relating to the ancient Greek architectural order distinguished especially by fluted columns on bases

Isometric perspective: a system using diagonal parallel lines to communicate depth

Kinetic art: a work that contains moving parts

Line: a mark, or implied mark, between two endpoints

Linear perspective: a system using imaginary sight lines to create the illusion of depth

Low relief: carving in which the design stands out only slightly from the background surface

Mass: a volume that has, or gives the illusion of having, weight, density, and bulk

Medium (plural **media**): the material on or from which an artist chooses to make a work of art, for example canvas and oil paint, marble, engraving, video, or architecture

Monochromatic: having one or more values of one color

Motif: a distinctive visual element, the recurrence of which is often characteristic of an artist's work

Motion: the effect of changing placement in time

Negative space: an empty space given shape by its surround, for example the right-pointing arrow between the E and x in FedEx

One-point perspective: a perspective system with a single vanishing point on the horizon

Optical mixture: when the eye blends two colors that are placed near each other, creating a new color

Organic: having irregular forms and shapes, as though derived from living organisms

Orthogonals: in perspective systems, imaginary sightlines extending from forms to the vanishing point

Pattern: an arrangement of predictably repeated elements

Perspective: the creation of the illusion of depth in a two-dimensional image by using mathematical principles

Plane: a flat surface

Positive shape: a shape defined by its surrounding empty space

Post-and-lintel construction: a horizontal beam (the lintel) supported by a post at either end

Principles: the "grammar" applied to the elements of art—contrast, balance, unity, variety, rhythm, emphasis, pattern, scale, proportion, and focal point

Proportion: the relationship in size between a work's individual parts and the whole

Retrospective: an exhibition of work that the artist has done in the past

Rhythm: the regular or ordered repetition of elements in the work

Saturation: the degree of purity of a color

Scale: the size of an object or an artwork relative to another object or artwork, or to a system of measurement

Self-taught art: art produced by people who have acquired their knowledge and skills by their own efforts, without formal education

Shade: a color darker in value than its purest state

Shape: a two-dimensional area, the boundaries of which are defined by lines or suggested by changes in color or value

Space: the distance between identifiable points or planes

Style: a characteristic way in which an artist or group of artists uses visual language to give a work an identifiable form of visual expression

Subordination: the opposite of emphasis; it draws our attention away from particular areas of a work

Temporary exhibit: an exhibit that is shown in a museum for a limited time, which will usually be several months

Texture: the surface quality of a work, for example fine/coarse, detailed/lacking in detail

Three-dimensional: having height, width, and depth

Tint: a color lighter in value than its purest state

Two-dimensional: having height and width

Unity: the imposition of order and harmony on a design

Value: the lightness or darkness of a plane or area

Vanishing point: the point in a work of art at which imaginary sight lines appear to converge, suggesting depth

Variety: the diversity of different ideas, media, and elements in a work

Volume: the space filled or enclosed by a three-dimensional figure or object

56 Diego de Silva y Velázquez, *Las Meninas*, c. 1656. Oil on canvas, 10'5¼" × 9'¾". Museo Nacional del Prado, Madrid, Spain

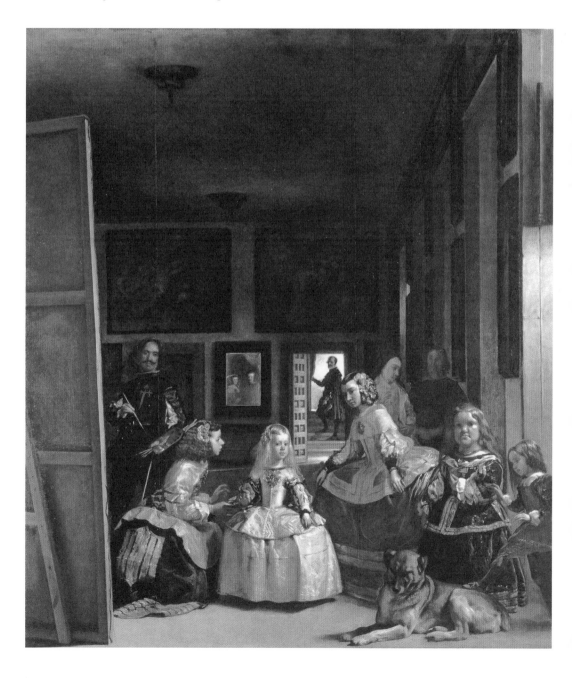